CHROMATIC

PURANG ABOLMAESUMI

JENNIFER BLACK

LARA BOYD

CARRIE JENKINS

HOI KONG

M.V. RAMANA

STEVEN REYNOLDS

MICHELLE STACK

SHEILA TEVES

Y-DANG TROEUNG

PETER
WALL

INSTITUTE FOR ADVANCED STUDIES
THE UNIVERSITY OF BRITISH COLUMBIA VANCOUVER

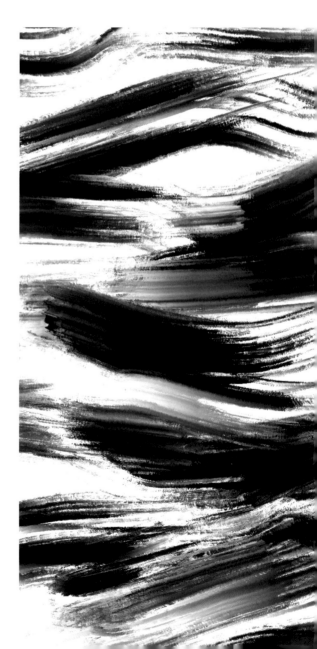

CHROMATIC

TEN MEDITATIONS ON CRISIS IN ART & LETTERS

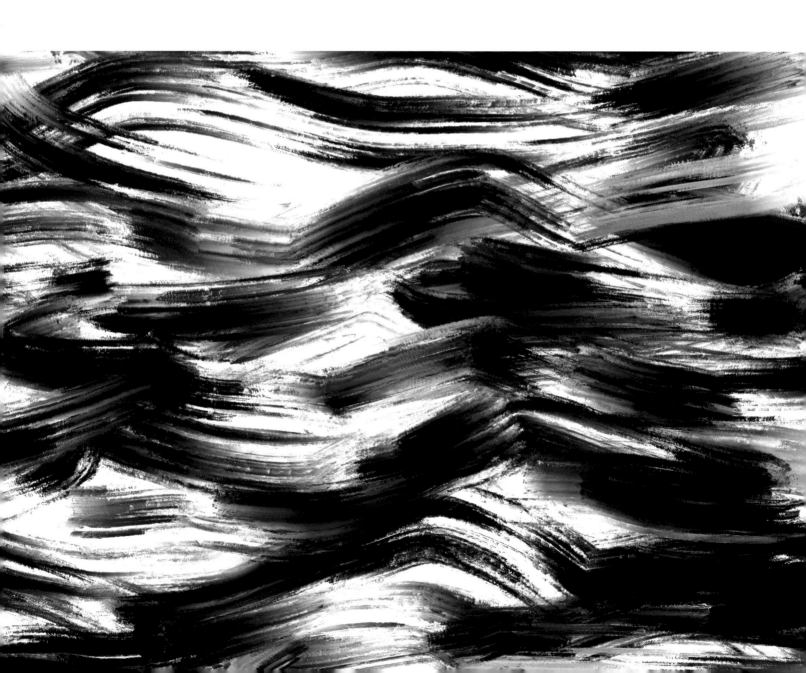

Peter Wall Institute for Advanced Studies
University of British Columbia
Vancouver, B.C.
pwias.ubc.ca

Cataloguing data available from Library and Archives Canada
ISBN 978-1-7752766-5-4 (paperback)

Cover and interior design by Jazmin Welch (fleck creative studio)
PWIAS Publishing Team: Robin Evans, Emma MacEntee, and Mary Rider
Copyediting by Lynn Slobogian
Proofreading by Alison Strobel
Cover and frontispiece art by Jazmin Welch (fleck creative studio)
Photo on page 46 by ZEIN AL-RIFAI/AFP via Getty Images
Printed and bound in Canada by Hemlock Printers Ltd.
Distributed by UBC Press, ubcpress.ca

PETER WALL
INSTITUTE FOR ADVANCED STUDIES
THE UNIVERSITY OF BRITISH COLUMBIA VANCOUVER

For Kalina Christoff, who brought us together
and supported us through a time of crisis.

CONTENTS

THE WALL SCHOLAR PROGRAM • The Wall Scholars constitute the signature program of the Peter Wall Institute for Advanced Studies. Since 2014, this program has brought together accomplished academic scholars and thinkers to engage in deep, unconstrained research in an immersive, interdisciplinary environment. During their year in residence, Wall Scholars come together to explore new ways of thinking about their own areas of expertise and challenge the assumptions about their individual fields of study through conversations that seek to uncover the unexpected. By providing an opportunity for sustained, regular, and close personal interactions among scholars across a multitude of disciplines, the Wall Scholars program forges lifelong partnerships among scholars who may never have interacted otherwise.

This book is a product of this unique program. It could not have been born in any other place. It is an example of the serendipity that arises in the process of forging close personal connections among scholars from fields as diverse as philosophy and engineering, medicine and law, literature and food systems.

From my own year in residence as a Wall Scholar in 2017, I know this is truly a once-in-a-lifetime opportunity. When the 2020 Wall Scholars first met as a cohort on March 11 during our annual Wallapalooza celebration, I could already see synergies growing around the dinner table.

In the following days we woke up to a changed world. The pandemic restrictions altered our lives in fundamental ways and brought to the forefront the multitude of crises that have long plagued us. As the storm of 2020 unfolded, the cohort embraced crisis as their theme, choosing to stay with the highly unsettling and almost insurmountable crises at the intersections of social justice, health care, economic inequality, and the environment.

This art book captures the creative energies that can only arise when an interdisciplinary cohort of scholars delve into such uncomfortable spaces and provide each other the intellectual and emotional support to stay in those spaces until new lenses of understanding present themselves.

DR. KALINA CHRISTOFF | *Interim Director, Peter Wall Institute for Advanced Studies (2019–2021)*

PREFACE

Nobody was ready for the academic year 2020/21. None of us got what we signed up for.

We — the authors of this collection — signed up to be Wall Scholars. We were going to spend a year talking and thinking together, learning from each other, sparking new ideas and research avenues. We were honoured and privileged to be the lucky few who got to experience this intense opportunity for collaboration across such diverse disciplines. When compared to the administrative busyness and frenzied rhythms of normal academic life, this is an incredibly rare and valuable experience. Instead we found ourselves in crisis. In fact, we found ourselves in multiple overlapping and intersecting crises. Individually, institutionally, collectively, nationally, and globally, the situation was critical.

The word *crisis* is etymologically derived from the Greek *krinein*, which means to decide. It comes to the English language via medical Latin; the crisis point in a disease is the moment that decides whether or not the patient will survive. The crisis is the turning point, the fork in the road. We can't go on as before.

We could not have the year we signed up for. We did not have our long talks over shared meals and intimate fireside gatherings. We were truly fortunate to have in Kalina Christoff a director passionate enough about collaboration to make the case for our having some masked and distanced in-person meetings on campus, until the COVID-19 situation deteriorated to the point where even this limited contact was no longer possible. We continued our collaborations online, over email, and, when possible, on outdoor walks. We became sick of Zoom and we lost many opportunities for research and engagement. But building on the ties that we developed in the fall, we made use of Zoom for forms of collaboration that couldn't have happened otherwise.

As scholars in crisis, we did what we could, what we knew how to do: we studied crises. As we talked and thought and felt our way through the year together, themes emerged. Crisis creates holes. Things go missing; old absences are revealed or amplified. Holes in our brain tissue, in social supports and medical care, in families, in classrooms, in landscapes — physical, regulatory, and political — and in science. Even our own little group was frequently missing a member because Steve Reynolds, a critical care physician, was so urgently needed elsewhere during this time.

We wanted to make something together, but our options were constrained. Still, art can be made — even flourish — within constraints. Art can also move in the world in ways traditional scholarship can't. It can address problems in different ways. We decided to make art together, calling in local artists to help translate and communicate our many perspectives on crisis.

Originally, we hoped for a physical exhibition, but as COVID progressed we had to put this idea on the back burner. So we have created this book, which is itself a kind of small exhibition and one that now takes on a more permanent form.

A chromatic scale is one that includes all the accidentals. It is so called because it is colourful, and the original meaning of *chromatic* is derived from the ancient Greek word for *colour*. In our collection, the serendipities and synchronicities of the academic year 2020/21 emerge as a kaleidoscope of responses to crisis in art and letters, words and colours.

DR. CARRIE JENKINS | *2020 Wall Scholar*

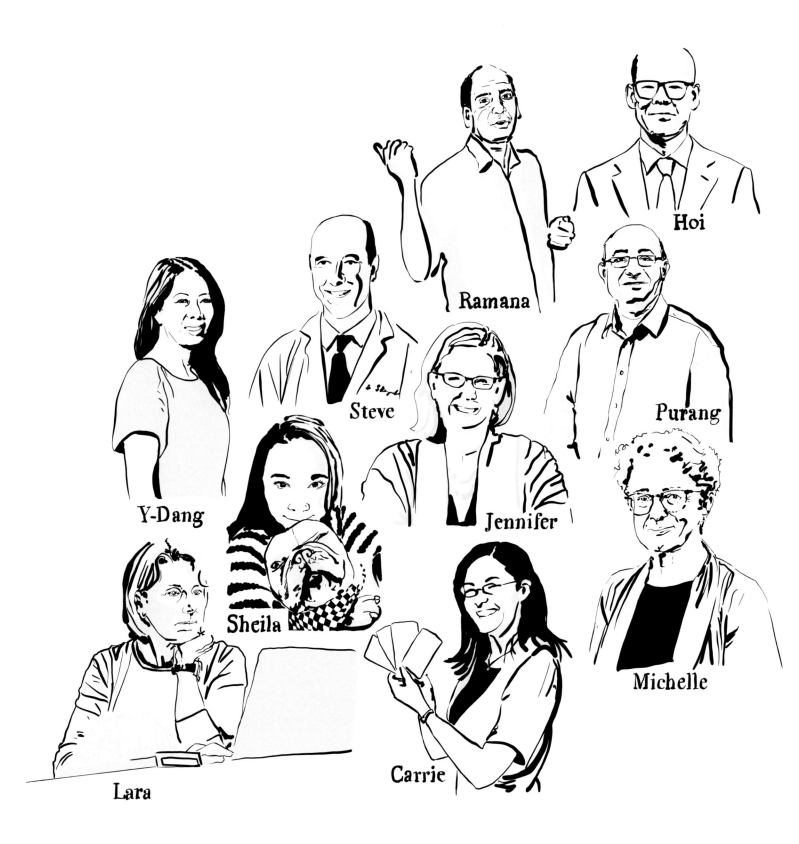

Ramana

Hoi

Steve

Purang

Y-Dang

Jennifer

Sheila

Michelle

Lara

Carrie

CONTRIBUTORS

PURANG ABOLMAESUMI

Purang designs innovative technologies that aim to move society from an individual-focused medical system toward more collective care. As a Wall Scholar, engagement with other scholars representing broad and diverse perspectives allowed him to explore new dimensions of creative design.

JENNIFER BLACK

Jennifer's work explores connections between food, nutrition, and health for individuals and communities. In this essay, she weaves in ideas inspired by fellow Wall Scholars related to how food teaches us about care and connection, and what can be done to mend holes in the food system made visible by COVID-19. She is inspired by the courageous and public forms of scholarship modelled by her fellow scholars.

LARA BOYD

Lara studies how behaviour and experience shape brain health. In this work, she explores how the brain responds to and recovers from crisis. This links to her work as a Wall Scholar to understand how engagement with art impacts the brain.

CARRIE JENKINS

Carrie is a philosophy professor, poet, and novelist who is fascinated by meaning, love, and madness in their many forms. For her, working with the scholar cohort has been an extraordinary opportunity to witness how other academics interpret the world and make meaning within it.

HOI KONG

Hoi's research explores the areas of constitutional and public law. His contribution to the book focuses on how constitutional processes can help societies in conflict move past crises. As a Wall Scholar, he had curiosity-driven conversations with generous and brilliant colleagues that led into uncharted intellectual terrain.

M.V. RAMANA

Ramana's research focuses on the political economy of nuclear energy and the many risks associated with that technology. As a Wall Scholar, he benefited from the camaraderie of other scholars willing to step beyond the disciplines they were trained in to pursue more open-ended intellectual pursuits. He also explored ways of engaging the public other than traditional academic writing.

STEVEN REYNOLDS

Steve is an intensive care unit physician and chief of staff at a busy tertiary care hospital. He worked on the front lines during the COVID-19 pandemic. He had planned to work on advocating for fiscal responsibility and sustainability of the B.C. health care system but was pulled into clinical and leadership work due to the pandemic. Despite this he was able to learn and deepen his thinking on this topic through his interaction with the other scholars and plans to re-focus on this in the coming years. He has been thankful for his time with the other Wall Scholars who have enriched his thinking and perspectives.

MICHELLE STACK

Through learning with other Wall Scholars, Michelle has expanded her research about rankings; co-ops and campuses; interprofessional education; and public scholarship. She used her time as a Wall Scholar to develop her capacity to share scholarship through standup comedy, satire, podcasting, and creative writing.

SHEILA TEVES

Sheila is a molecular biologist studying how cells determine identity and function. As a Wall Scholar, Sheila explored how injustices in society are reflected in who and what is valued in the natural sciences. Her views on social justice were shaped by inputs and lessons from other scholars.

Y-DANG TROEUNG

Y-Dang's research examines narratives of war and refuge. Her contribution is a meditation on the ongoing crisis of permanent war, from Cambodia to Yemen. The essay emerged from interdisciplinary conversations about the intractability of our times.

TRYPOPHOBIA

Noun. Aversion to or phobia of small holes.

LARA BOYD

Art by April dela Noche Milne

LACUNES • *Noun.* (1) A blank space or a missing part. (2) A small cavity or pit.

Holes can be frightening, especially when they are in the brain.

When holes in the brain are very small (about 1 mm), they are called *lacunes*. These small holes are the result of brain damage from disruptions in blood flow (i.e., strokes) that cause brain cells to die. Most often lacunes occur deep inside the brain where it is hardest for blood to reach. The quantity of lacunes increases with age; higher numbers relate to poorer brain health.

Interestingly, there can be many lacunes in the brain without an effect on brain function. At some point the accumulation of lacunes becomes pathological, and their presence causes a crisis, disrupting the ability to think, plan, or move. But the threshold for the number of lacunes or the amount of brain that is damaged before function is lost differs between individuals. Scientists do not know why.

Many things may cause lacunes: increasing age, high blood pressure, poor diet, inflammation, and, in some people, COVID-19. Other than age, the risk factors for lacunes are modifiable.

PENUMBRA • *Noun.* (1) A space of partial illumination (as in an eclipse) between shadow and light. (2) The area surrounding a stroke or lacune.

Early after a lacune emerges, the region directly surrounding the damaged brain is physiologically very active; this area is called the *penumbra*. Brain cells within the penumbra are highly neuroplastic; they react to brain damage by rapidly re-organizing their connections to other cells. In addition, the chemistry in the penumbra shifts to protect cells that are damaged and, at the same time, to speed the dying of other cells.

The net result is that neurons in the penumbra can change their primary function to take over the tasks of damaged or dead cells. In this way, brain cells in the penumbra adapt their purpose and eclipse the function of lost cells. Despite this rush of activity, the damaged parts of the brain never totally recover. Yet a new type of brain function becomes possible, one that is now driven by the activity of neurons in the penumbra.

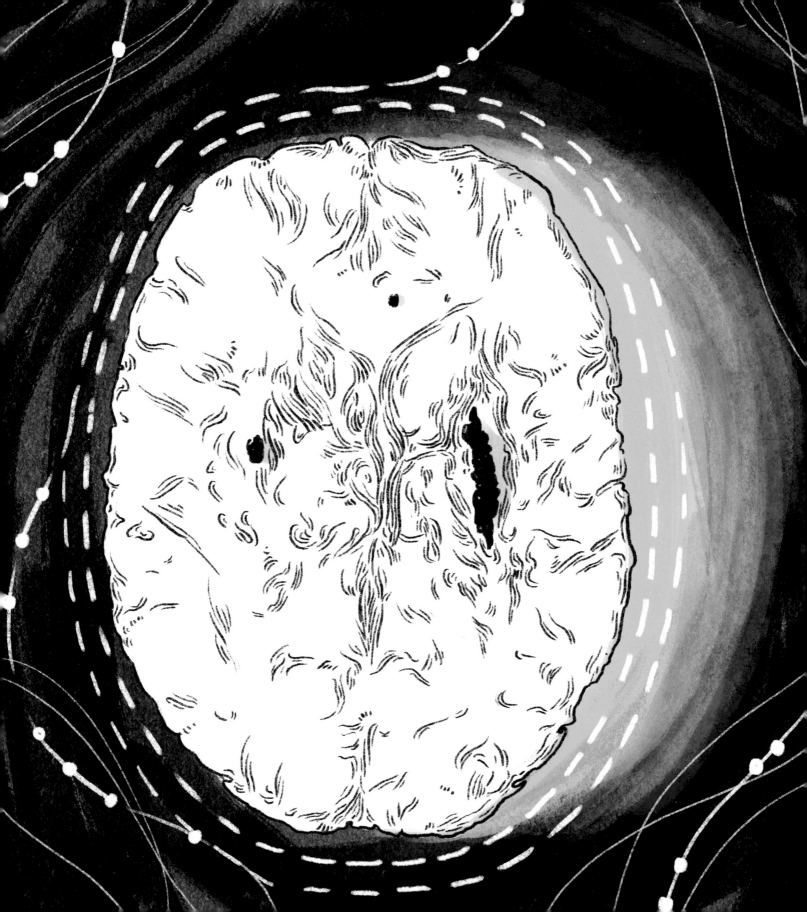

RECOVERY • *Synonyms*: recapture, reclamation, recoupment, repossession, retrieval

Lacunes cause a health crisis. Yet, despite their presence in the brain, recovery does take place. Critically, the process of recovery is driven almost entirely by our behaviour. There is no drug or medical intervention that stimulates change in the brain as effectively as the activities we choose to engage in. In this way we shape how both the penumbra and whole brain re-organize after damage.

Engaging in little or no activity causes lesions to increase in size, and neurons in the penumbra are silent. Alternately, practising meaningful behaviour stimulates activity in cells in the penumbra and also throughout the entire brain. In turn, this activity promotes neuroplasticity and supports the recovery of functions that were lost.

While these processes enable the restoration of function, after damage the brain is never the same. Though this is frightening, recovery occurs as something new and different emerges.

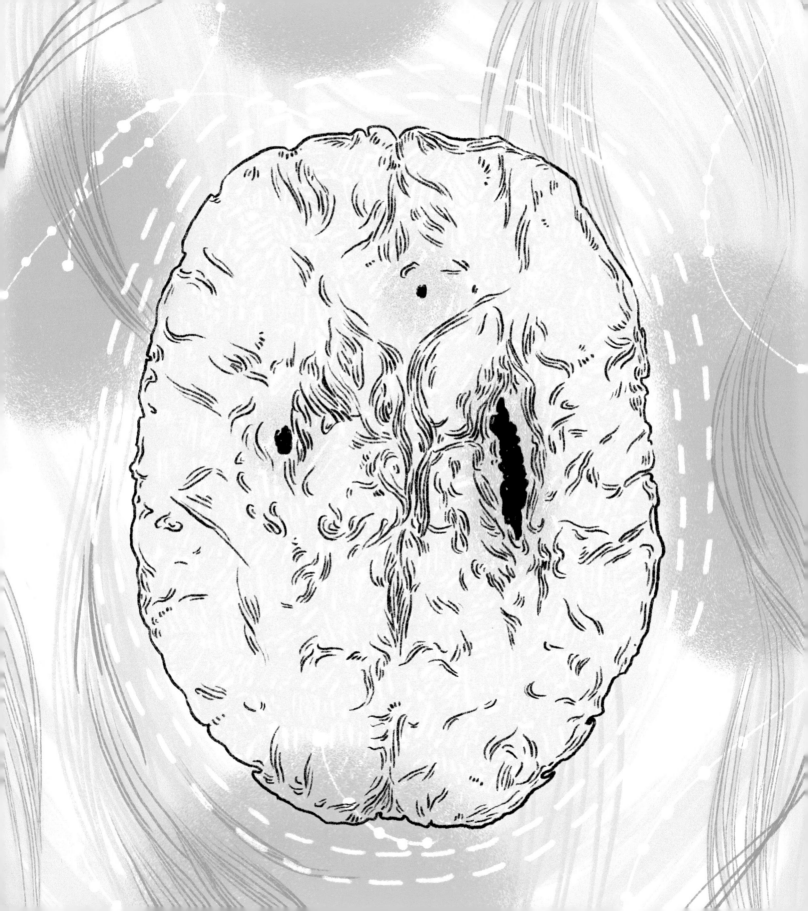

THOUGHTS ON FOOD AND CONNECTION IN AND AFTER CRISIS

JENNIFER BLACK

Art by Lay Hoon Ho

Food is a basic necessity but also the glue that binds us to family and community. Eating is a vital part of our daily routines and holiday rituals, and a way that we can express care for others and nurture our bodies. Yet national survey data from 2017–2018 finds that over one in eight Canadian households reported experiencing *food insecurity*, defined as having inadequate or insecure access to food because of financial constraints.

Researchers sometimes categorize food insecurity on a spectrum. Its mildest form begins with the nagging worry that food might run out without money to access more. The next stage demands a compromise in the amount or quality of food available. In its most severe forms, food insecurity can mean missing meals or going whole days without food. In my work as a dietitian and nutrition researcher, I have documented food insecurity's brutal toll on the physical, mental, and spiritual well-being of people who cannot care for their food needs with dignity. I have also come to see how food can heal and connect and build relationships among people and with the land.

When COVID-19 struck in 2020, rates of food insecurity surged, leaving over 5 million Canadians worried that they did not have enough money to feed themselves or their families. The communities most affected by food insecurity also faced higher risks of COVID-19 exposure and suffered the deepest economic and mental health consequences of the economic and social lockdowns.

Even before the pandemic, access to sufficient food was a challenge for many Canadians, particularly families with children; single mothers; residents of northern communities; people with disabilities, on social assistance, with low incomes, living in isolation, or lacking material assets or community supports; and Black, Indigenous, and other racialized Canadians. Despite common stereotypes about people living in poverty, the majority of food insecure Canadians are employed and actively contribute to the workforce but do not earn enough income to meet their food needs. While many higher-waged and professional workers were able to work from home during the pandemic,

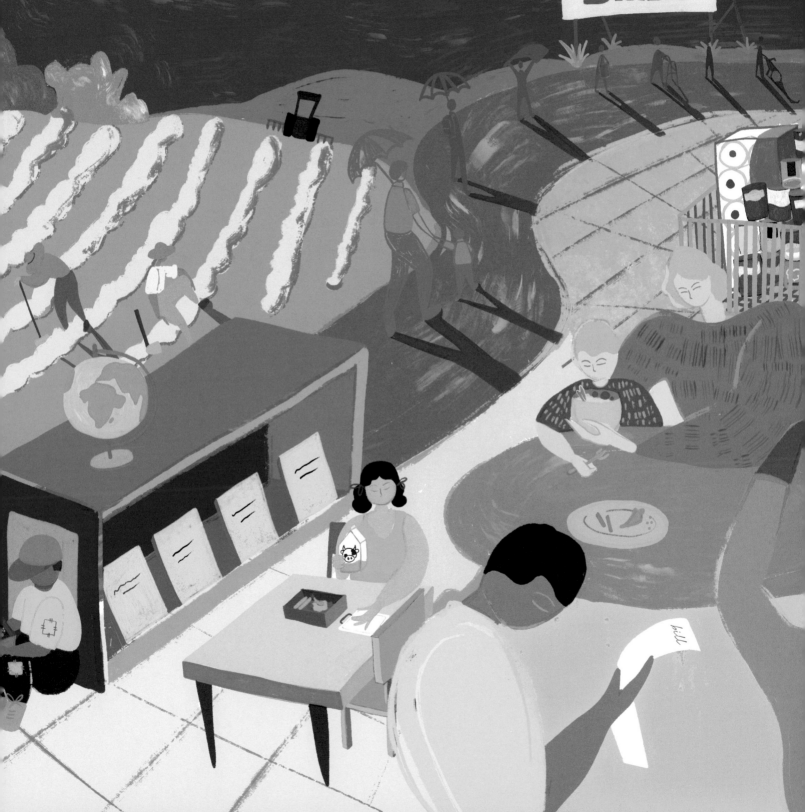

it was many of these low-paid and precarious workers — particularly women and younger people — who endured sudden job losses and cuts to their working hours, pushing them ever further from the security of knowing they could access the foods they need. While COVID-19 has helped shine a new light on some of these struggles through research and media coverage, many stories remain untold and invisible, including those of refugees and undocumented workers, some of them filling essential roles working in Canada's food system.

To support struggling families, the federal government quickly rolled out a variety of income support programs, including the Canada Emergency Response Benefit, tax credits, child benefit payments, and wage subsidies for employers, and we have much to learn about the extent to which these supports buffered people from the storm. But it's clear that efforts to ensure adequate income for all to meet their food needs were not enough, and that some investments that offered 'feel-good vibes' ran counter to evidence about what meaningfully helps. For example, in April 2020 and then again in October 2020 — preceding the Easter and Thanksgiving holidays — the federal government announced unprecedented funding of $100 million each time to fund food banks and charitable food providers. Rather than ensuring adequate income supports were in place, the prime minister and other elected leaders publicly urged people in need to turn to food banks and asked Canadians to chip in extra cans for food drives. But less than 1 in 10 food insecure Canadians ever accessed a food bank during the pandemic, and years of research show that those who do rarely have their basic needs met by charity-based efforts. Food banks have simply not been an effective or dignified solution to food insecurity. Many neighbourhoods don't have an accessible food bank or one with convenient hours. Food banks seldom have the quantity or variety of foods that people need or want and are a strategy of last resort used mainly by those in the direst of straits.

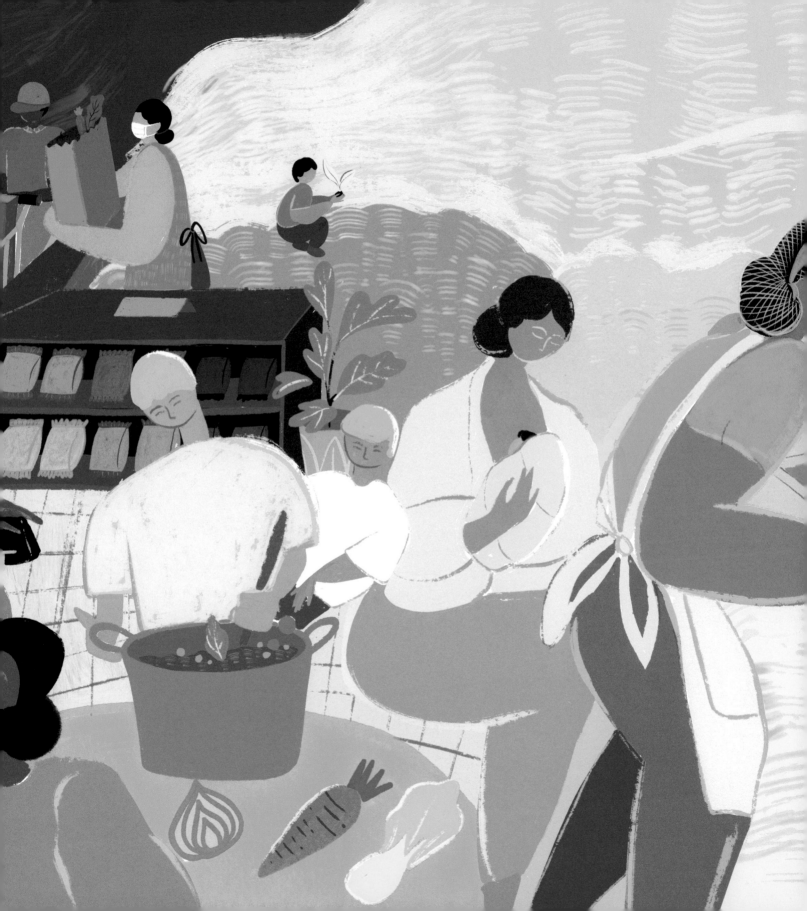

Still, food served as an important source of comfort and connection during COVID-19 lockdowns. People took up gardening and baking at astonishing rates, and some families enjoyed additional time preparing and sharing meals at home with loved ones. Others learned how to access groceries through delivery services or cared for elders or vulnerable neighbours by delivering food to those sheltering at home. But COVID-19 also taught us important lessons about the essential and often undervalued work of those responsible for food work, including those who grow, process, cook, and serve the foods we rely on. The care and effort required for feeding others was already well known to the many women and caregivers suddenly charged with feeding their families around the clock as schools and daycares closed, many of whom were also juggling working for pay and supporting other vital community care roles. Other food workers, some of whom experienced food insecurity first-hand, faced direct exposure to COVID-19 outbreaks as they filled essential workforce jobs of feeding the elderly in long-term care or working as farm labourers or as employees in meat-packing and food-processing plants.

Will COVID-19 help policy makers and those who vote for them to value and ensure the right to food for all and to recognize that the land, water, and people who feed us are all essential? To fill the holes made clear by COVID-19, post-pandemic policies will need to guarantee that everyone has sufficient income to meet their food needs with dignity and that the work and care required to feed is a more evenly shared responsibility.

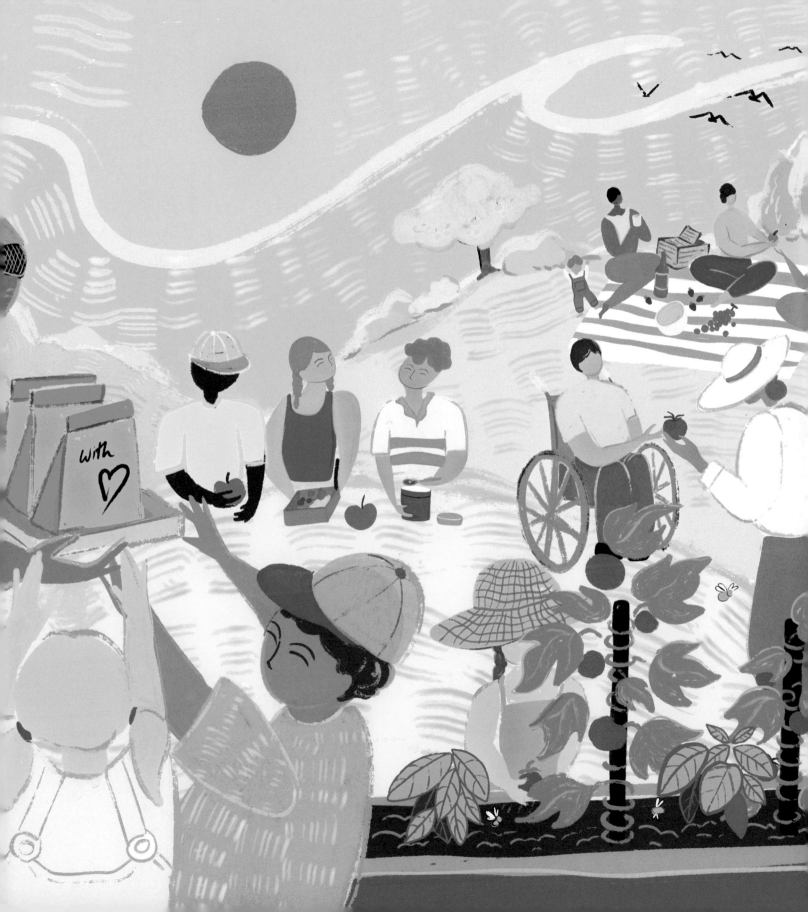

TOWARD A COLLECTIVE WILL TO DEMOCRATIZE CARE

PURANG ABOLMAESUMI

Art by Sandeep Johal

OUR CARE IN CRISIS • Avery and Alex both develop similar chest pains and seek help. But here's the difference: Avery lives in Vancouver and Alex lives in rural B.C. Their respective care journeys are very different and this can have a profound impact on their health.

Avery drives to the nearest emergency room. She is sent right away to radiology, where she is determined to be at high risk for a heart attack. Avery sees a cardiologist on the same day.

Alex, on the other hand, goes to see her doctor, a general practitioner (GP), who sends her to a local clinic for tests. The GP gets the results the next day and sends Alex for X-ray imaging. After another day, the GP tells Alex she needs ultrasound imaging of her heart. However, the GP does not have any training for it, and there is no specialist for heart ultrasound imaging at the local clinic. So, the GP refers Alex to a specialist at an imaging centre two to three hours away, for more advanced ultrasound imaging of the heart. In the meantime, Alex's chest pain is getting worse and she cannot wait to see the specialist. Alex is finally airlifted to Vancouver for emergency heart surgery. For Alex, this was a very close call.

This is the daily story of many patients who live in our province. Those in rural and remote areas of B.C. have little local access to the quality of care many people in urban centres take for granted. The problem has been exacerbated by COVID-19 but has been around for many decades. It is also not limited to heart attacks, any specific organs, or diagnostic procedures. For example, clinical guidelines recommend that all pregnant women be assessed in the early stages of pregnancy with ultrasound imaging. Poor access to imaging may be potentially life threatening for mothers if complications are not detected early. The problem is magnified in even more remote communities.

It doesn't have to be this way. While the problem of providing quality health care to remote areas is multifaceted and requires fundamental change in socio-economic factors, recent technological advancements provide unique opportunities to do better and improve lives. Imagine an alternative scenario where inexpensive technologies, such as point-of-care ultrasound imaging, help expand more equitable access to care anywhere in our province.

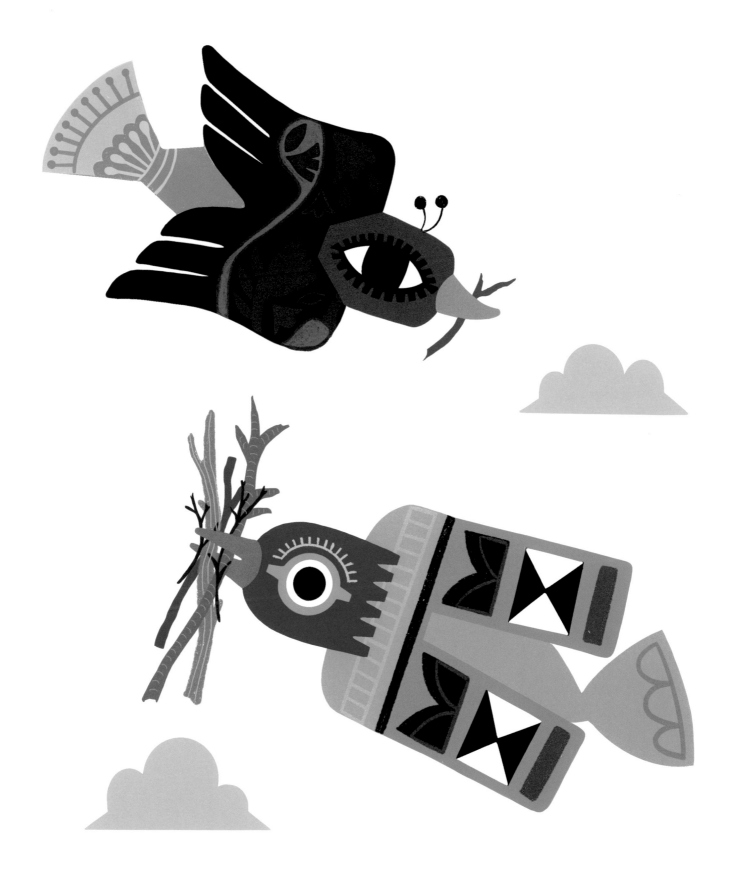

IS THERE A POTENTIAL SOLUTION ON THE HORIZON? • The development of miniaturized, inexpensive ultrasound imaging devices that connect directly to a GP's phone is paving the way to reducing diagnosis barriers at point of care in remote and urban areas alike. However, there is still the challenge of training. Accurately identifying disease through ultrasound examinations requires years of experience. A potential solution is to use technologies, such as virtual telepresence, to remotely connect the GP with a specialist in an urban centre who can provide guidance for ultrasound imaging. However, this solution is not scalable given the limited number of specialists available.

Another alternative is to use artificial intelligence (AI) to learn from experts how to acquire high-quality data and make a diagnostic decision. By integrating AI with ultrasound imaging on the GP's phone, the GP can be supported throughout the entire diagnostic process. This new paradigm also provides patients with an explanation for AI's suggestion of a specific diagnosis or intervention.

There are many technological challenges still to resolve, such as how to ensure the privacy of patient data, and also legitimate ethical questions to answer, such as the unfair advantage this technology may give to certain commercial entities that would use public and private data to develop AI. Identifying and addressing these and similar issues will be critical. It requires continuous dialogue between researchers, technology companies, and the public, so that an explainable AI technology can be designed alongside all the requirements and constraints identified through user engagement. Such an exchange and synthesis of knowledge across all stakeholders will be essential for the development of ethically sound, publicly acceptable, and commercially viable AI technology.

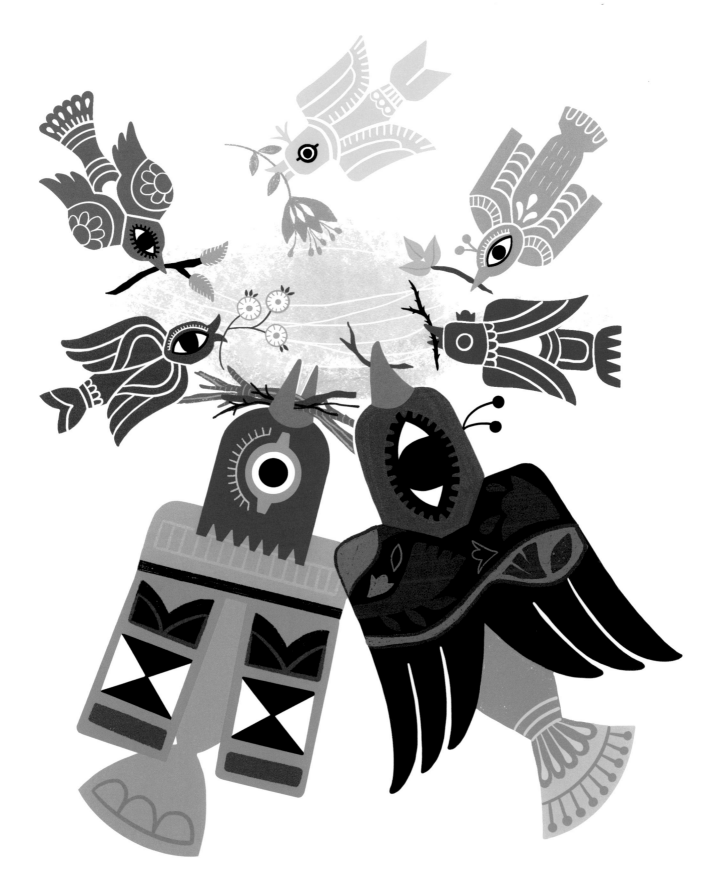

SO, LET'S BUILD A COLLECTIVE CARE SYSTEM • For Avery and Alex, life is very different now. Whenever Avery visits a health care practitioner in Vancouver, she knows that, in addition to receiving the best care possible, she is also directly contributing to improving the care of everyone in our province. By making her data available — securely and privately — AI will learn from her experience and apply it to others' situations.

For Alex, on her next visit her GP uses a small ultrasound device to scan Alex's heart, and the images appear immediately on their phones. During scanning, the GP is prompted by suggestions from AI about the next steps of the diagnosis and treatment journey for Alex, based on AI's interpretation of the images. AI explains its suggestions, so the GP and Alex can discuss the best course of action. This may also involve consultation with a specialist in Vancouver who can be brought in by the GP to see the ultrasound images live on the phone. AI is trained using Avery's and many others' data collected from large urban centres, such as Vancouver, and in rural regions as well.

Harnessing AI learning and closing the gap between the health care delivered to Avery and Alex will directly affect the fabric of our society. People will have access to the same level of care no matter where they live. It's likely this change in access to care will affect the way people make decisions about where they want to live and work. Let's follow up with Avery and Alex in the years to come to see if this will in fact be the case.

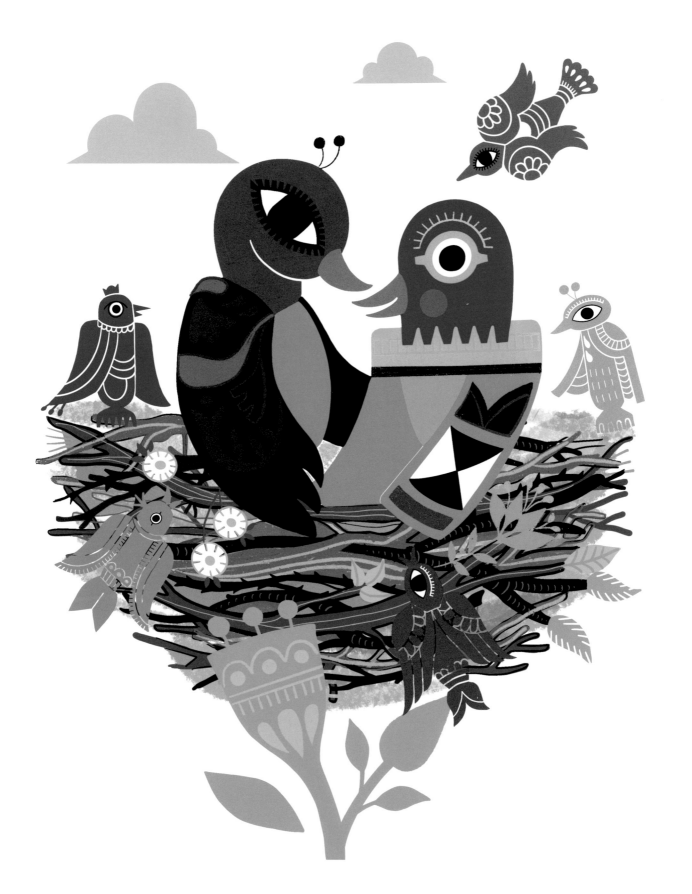

EPI[ON] DEMOS[PEOPLE]

STEVEN REYNOLDS

Art by Jess Stanley

FALL • Another ping from my cellphone. I'm mildly annoyed at the disruption while I'm trying to review my patients in detail. I pick up my phone to look at the text. It's from a friend: "So, 7 out of the past 9 days on skis, skiing this morning, and ride Seymour this afternoon."

My heart sinks. A snap of envy stops me in my tracks. Frustration startles me with its ferocity. I'm surprised to find that I can't focus.

I put my phone down on the mobile rounding table we take to patients' bedsides and signal the nurse to give me a few moments before delivering her report on the next patient.

———

Growing up, I wanted so badly to contribute, to build up those around me, and to be valued for that. Medicine was the right fit: the challenge, intellectual puzzles, service, and meaning, all together. A focus, a push, a stretch.

I remember the moment when my life shifted from adventurous youth to lifelong commitment. I sat on a black sand beach on the island of Makira in the Solomon Islands and watched the sun rise. Even at 20, I knew that those days were limited.

Now, on the cusp of 50, I can see the consequences of that decision. I have contracted tuberculosis and received an HIV-positive needle stick. COVID-19 is just one more set of sacrifices, and I now spend days facing down this virus. Nights away from my family. Vitality spent in the early hours of the morning squinting through the fatigue, staring at a patient's monitor, trying to gather the sands of a patient's breaking physiology in my hands. Sometimes pulling out a success. Too often I am unable to change the course.

COVID has been a sacrifice for us all. We've all lost, in small and big ways. Part of this loss is apparent to me in the text I received from my friend — what I have traded for my calling, what I continue to forsake in the deluge of work. It's good, it's important, but I've given my work a portion of my soul. What I feel most now is the many absences: of freedom, of the liminal release of vacation, of gathering with friends, of spontaneity, of rest.

But this is not the time for rumination. The team is waiting. There is urgency in the illness all around me in the ICU. Some days I drown in the meaning that I've chosen, but I know I wouldn't change it for the world. Not even for seven out of the past nine days on skis.

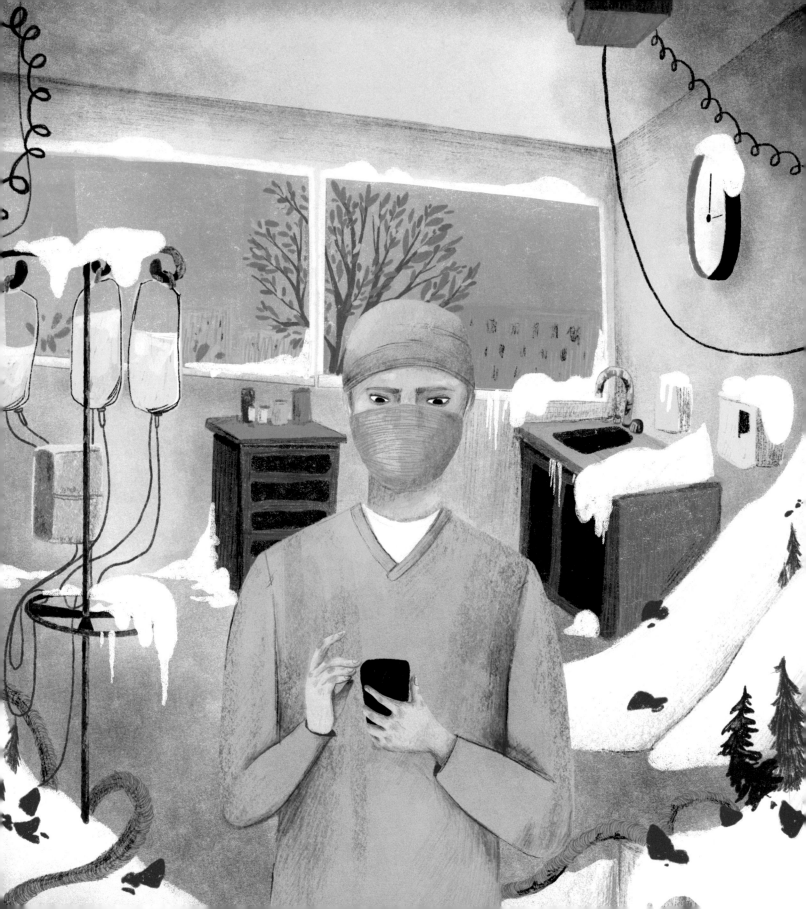

WINTER

I am gone
Physically. Emotionally. For the times
I arrive,
I am worn and rageful in equal measure. Every email contains a hidden slight, every slight is
An act of war.
In my silence, I writhe in discontent. Groping to find
My way back.

SPRING • I've always thought that the 7 p.m. displays of appreciation — the joyful cheering and the banging on pans, the signs and the notes of thanks — were really more for someone else.

After all, it's the nurses who are in the rooms with the ICU patients constantly, the respiratory therapists who tirelessly change the mechanical ventilators and suction secretions. I know deep down in my soul that what really makes patients with COVID — and most ICU patients — better is good care by people who know what they are doing. More than just knowing it, they apply it in everything they do. They take care of all the small things, and those small things add up to saving lives. That's why I'm proud to work where I do, because I see this every day in the folks around me.

So, it's always seemed to me that the nurses and respiratory therapists are more apt targets for the outpourings of appreciation. Hour after hour, they are the ones who show the quiet courage necessary to support people through the direst of times.

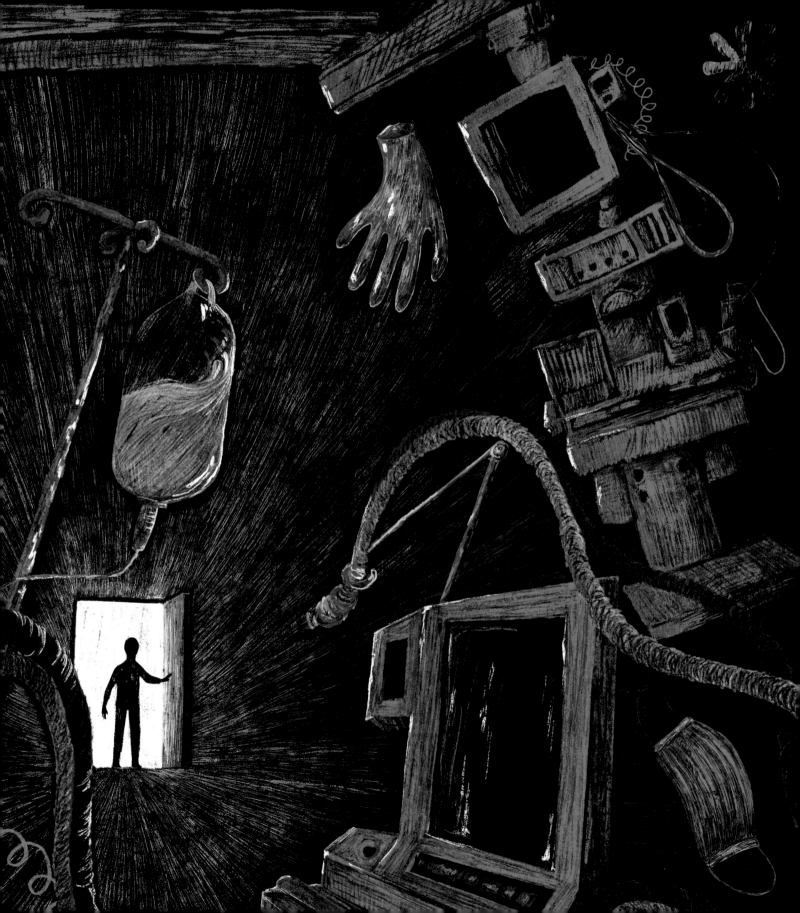

Today was different. Today I would spend hours with COVID-positive patients, moving a camera through their lungs while cleaning out secretions and taking samples. Not a glamorous part of my job but necessary to help the lungs open up and to optimize their function in the sickest of patients.

Much of what we do is to minimize stirring up the virus, to keep it quiescent in the lungs as much possible. Prevention is far better than protection. Today I knew I couldn't do that. I was kicking the hornet's nest today.

Before I started, I asked everyone to leave the room. No need to expose others for the luxury of having more hands around. They could come in if needed. In each conversation I could see their calculations as they thought through the next hour or two. They would be there if I needed them.

As I started the first bronchoscopy, with all of the necessary tools laid out in an array, I had a quiet moment of realization. There was no doubt that the virus was on the other side of my mask. I marvelled again that something so silent could upend everything we knew. It was there. Waiting for me to mess up. Thick in a cloud.

I'm experienced at using personal protective equipment. I knew that even if I got COVID, it was likely to be a cold or at worst a flu-like illness. The numbers said I would be fine. Large numbers make sense in terms of the science. I would very likely be part of the vast majority that only have minor symptoms. That doesn't reconcile with the emotional impact of the stories out of New York and Lombardy, of colleagues who have sickened or died from the disease.

Panic tickled at the edge of my awareness.

Calm, settle, focus. No getting around it. This needed to be done.

I decided to push through all the procedures I had lined up. I skipped breaks in an effort to conserve personal protective equipment and avoid doffing my equipment. By the end of hour five, I was tired and frustrated. The inside of my mask smelled foul, like the assault when first entering a barn but with no reprieve. I was sweating through my three layers and had resorted to muttering to myself.

I finished. I paused and resettled my focus to remove my outer protective layer cautiously. This was where mistakes were often made. These last few moments where all of my efforts at self-protection could come undone. I felt battered but had to summon the deliberate concentration to pay attention to each small step. After I was done, I felt like flopping into my car and driving home to see my family. I had to gather the energy to shower before I left, and I lost myself under the hot water.

As I walked to my car I reflected on my actions — if I had been cavalier; if I could have avoided the procedures. No, it needed to be done. I knew that finding an excuse to avoid it was tempting. What I did today was part of the constant attention to detail at the core of good ICU care.

I was unlocking my car as the parade of ambulance and police cars began their 7 p.m. ritual. The sharp sound of sirens mixed with the clapping and cheering. The metallic sound of pots in the distance from multiple balconies. I paused and teared up.

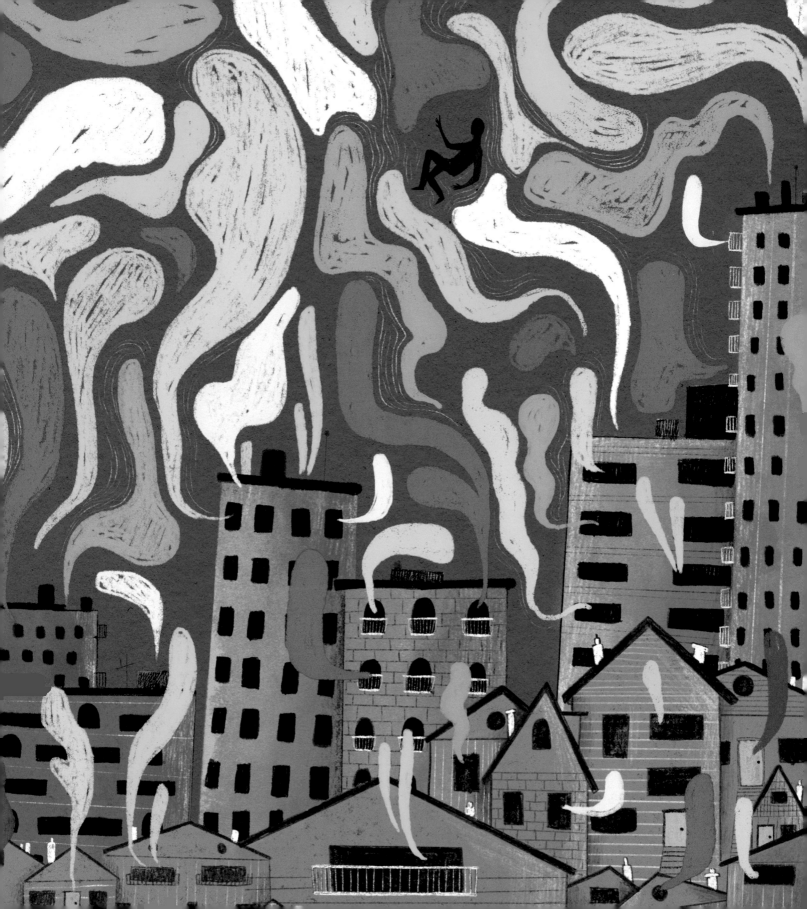

THE FUKUSHIMA NUCLEAR CRISIS

M.V. RAMANA
Art by Ulrike Zöllner

HOLES IN BUILDINGS • Decades before the Fukushima Daiichi Nuclear Power Station underwent a series of explosions in March 2011, Japan's policy makers and its nuclear industry had bought into — and perpetuated — a powerful fantasy. The safety myth held that nuclear power plants would never suffer accidents. The belief was critical to Japan's buildup of nuclear power, and it took hard work to maintain that belief.

Even when nuclear plants failed in unexpected ways, the nuclear industry continued to avoid imagining the obvious. In 2007, for example, a powerful earthquake opened up a hole in the outer wall of the Kashiwazaki-Kariwa Nuclear Power Station, allowing the release of radioactive water. The opening up of that hole had been, an official from the Tokyo Electric Power Company (TEPCO) confessed, "beyond our imagination".

This unwillingness to consider catastrophic accidents allowed TEPCO to build nuclear plants in places like Fukushima without planning for the kind of flooding that ultimately destroyed the Daiichi plant. Japan has a long history of tsunamis; it has been known since 1990 that a very large tsunami had struck the Sendai plain not far from Fukushima in the year 869. TEPCO downplayed these risks and continued operating its nuclear plants. Japan's regulatory agency did not stop TEPCO. Such gaps in Japan's nuclear institutions and processes led to the Fukushima Daiichi reactors exploding, creating holes of a different kind in buildings.

Safety myths and holes in regulatory structures are not unique to Japan. Other countries also ignore obvious hazards. An example is the practice of building multiple reactors in a single location. The 2011 disaster in Fukushima showed the dangers of this practice; accidents at one reactor make accidents at nearby ones more likely and emergency actions harder to undertake. Yet, the U.S. Nuclear Regulatory Commission is in the process of approving a new reactor design called *NuScale*. To cut costs, NuScale would like to build 12 reactors at each plant. They refuse to imagine the obvious. It reminds one of author Upton Sinclair's quip: "It is difficult to get a man to understand something when his salary depends upon his not understanding it."

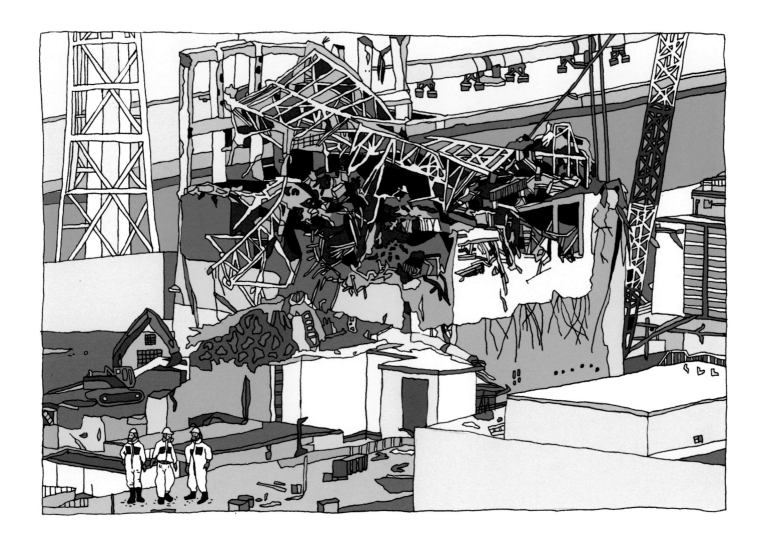

HOLES IN POPULATION MAPS • The Fukushima nuclear disaster resulted in fallout, a complex cocktail of radioactive materials, spreading across Japan. Among these radioactive elements, cesium-137 — which emits penetrating gamma rays as it decays — is a particular threat to health.

In recent decades, the largest quantity of cesium-137 injected into the atmosphere was from the Chernobyl accident of 1986. Thirty-five years later, large tracts in Belarus and Ukraine remain uninhabitable because they are contaminated with high levels of cesium-137.

Fukushima, too, has resulted in such areas. In regions where concentrations of cesium-137 were expected to be high, inhabitants were evacuated. They became refugees within their own country, their land poisoned for decades to come.

The relatively small size of the evacuated areas is due to luck. The wind blew much of the fallout into the Pacific Ocean, away from the inhabitants of Japan (although some of it could come back through the fish harvested from the ocean).

But there was an even greater stroke of luck. Soon after the Fukushima disaster started, Prime Minister Naoto Kan asked the Japan Atomic Energy Commission (JAEC) about the various ways in which the accident might unfold. One particularly worrisome scenario involved a fire in a pool used to store the radioactive fuel already irradiated in these reactors. JAEC estimated that, if this scenario materialized, people living up to 170 km from the accident site might have to be compulsorily evacuated and those living up to 250 km away encouraged to voluntarily move out. Had the wind been blowing toward Tokyo, 225 km from the Fukushima Daiichi nuclear plant, then the capital city and nearby areas might have had to be vacated.

This scenario was only averted because water that had coincidentally been stored in one of the reactors for routine maintenance purposes flowed into the spent fuel pools, preventing a fire. Years later, Kan reflected on this scenario: "If 50 million people had, in fact, been evacuated, the confusion and adversity that awaited them would have been truly unimaginable. And this was not an ideal fantasy. It was so close to becoming a reality."

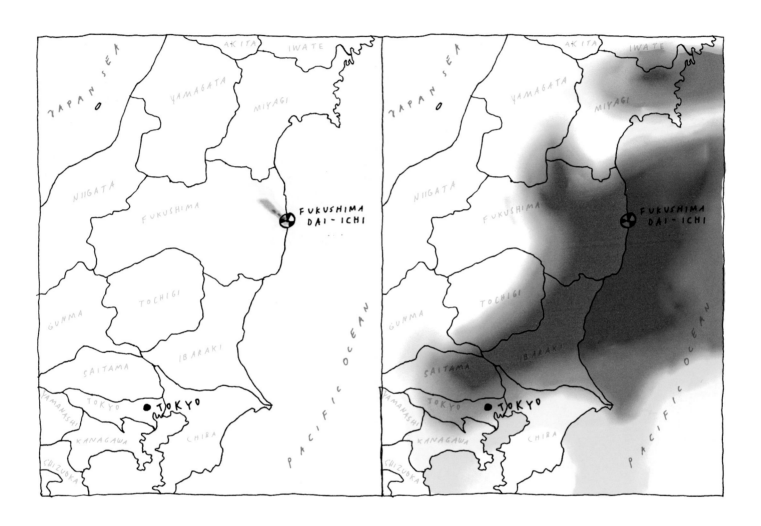

HOLES IN COMMUNITIES • Years ago, visitors to the town of Futaba would be greeted by an archway over its main street, declaring in bold letters, 'Nuclear power: the energy for a bright future.' A sixth-grade student, Yuji Onuma, invented the slogan and won a prize from the mayor for it.

Today, visitors to Futaba would be greeted very differently — by rows of derelict buildings, abandoned shops, crumbling roofs, cracked pavements, and former rice fields stacked with black plastic bags filled with irradiated soil. The once-bustling town is too radioactive to be inhabitable. The former inhabitants of Futaba are among the approximately 160,000 people that were evacuated from the vicinity of Fukushima.

Futaba today is an exception not because of its high levels of radioactivity, but because the Japanese government hasn't yet declared it safe enough for rehabitation, despite their creation of a hole in the regulatory standards for radiation exposure. Now people within the Fukushima prefecture can legally be exposed to 20 times the radiation levels allowed in pre-accident times.

Most people haven't bought the safety myth this time around, and only a small fraction of the evacuees have actually moved back. Those who moved back did so to half-empty towns with many essential services unavailable and neighbours and friends no longer there to provide a sense of community.

Futaba reminds us of what could happen in the vicinity of any nuclear plant. There might be one terrible day when communities are told to move out, possibly never to come back to their homes. Such an event might be rare but it is certainly possible. It happened to towns like Pripyat near Chernobyl too. This is perhaps why Onuma, now in his 40s, made a placard to modify his prize-winning slogan. He held it up in front of the sign, changing it to read 'Nuclear power, [the] uncontrollable energy.' Beyond his or anyone's control, nuclear energy has destroyed his whole community.

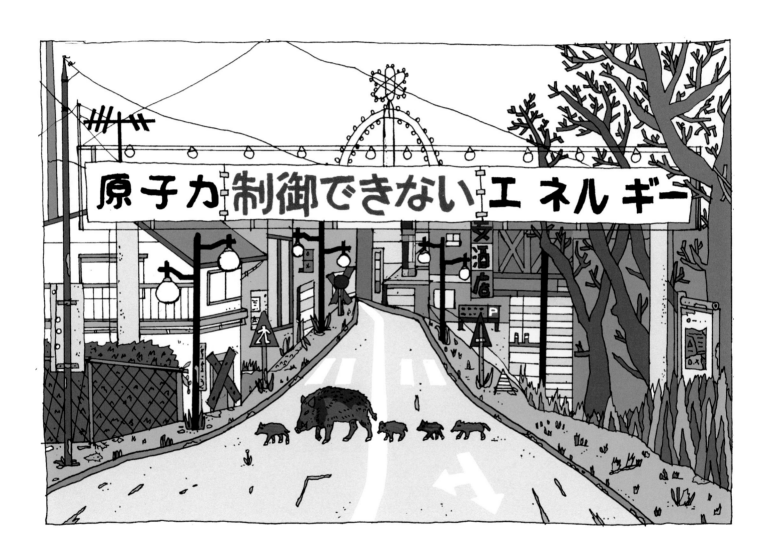

THE CRISIS OF PERMANENT WAR

Y-DANG TROEUNG

Art by Ulrike Zöllner

BROKEN SEED • In Cambodia, where my parents were born, bombs are called *kro bike*, which literally means broken seed. From 1965 to 1973, the U.S. military dropped 2.7 million tonnes of these bombs on their homeland. Cambodia, once known as an island of peace, wanted no part in the Vietnam War, but the bombs kept arriving. What the U.S. euphemistically called Operation Freedom Deal transformed Cambodia's lush, tropical landscape into a scarred surface, freckled with hollowed-out spots. Not all of the bombs detonated right away. Some lay dormant for years, just beneath the earth's skin, until they began to fragment, one by one, triggered by small hands and footsteps looking for toys and food. Today, 50 years later, these broken seeds are still sprouting up from the poisoned ground, adding to the ticker of the war's body counts and maimings. In the watery craters that Cambodian people today call *bomb ponds*, fragile little ecosystems now grow.

Elsewhere in the world new seeds of war are being planted. Syria today, like Cambodia in the '60s and '70s, is the terrain of a deadly *proxy war*. Both countries have been likened to chess pieces in the war games of the global superpowers. To wage proxy war is to find a sacrifice zone elsewhere for one's battle. It is the small board for the aspirations of the big players, for the hot experiments of the Cold War technicians. Yet in these terrains of hot fighting — 'off the map' of the world's radar — people continue to do what they can to survive. We see this capacity in a surreal photo of a man collecting vegetables from a garden patch in Aleppo, Syria, in 2014. He looks to be in his 30s, around the same age my father was during the war in Cambodia. He kneels in the middle of a bright green, circular vegetable patch, balancing three round, white gourds in his hands. The quotidian banality of the foreground stands in stark contrast to the grotesque backdrop — a city in ruins. Behind the man rises a wall of collapsed concrete homes, destroyed by explosive-packed barrel bombs tossed from hovering helicopters. The flowering garden patch is the result of a barrel bomb hitting a sewage pipe. When and where does the crisis of war begin and end?

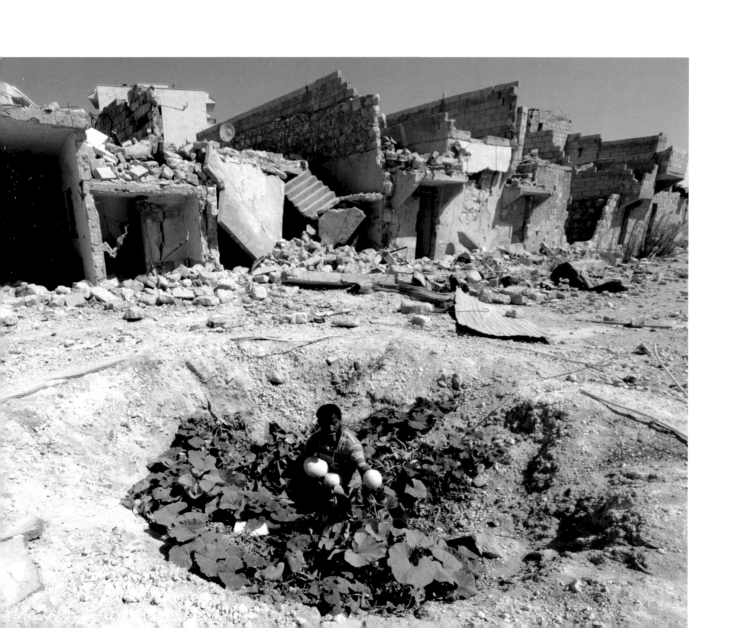

WAVE • The most common kind of injury suffered by people in war zones is called a *concussive wave*. When a bomb hits the earth, it sends a shock wave through the air that radiates outward. The effects of these waves on the body and mind are not well studied, but doctors speak of "blast-associated traumatic brain injuries", tear connections, shock waves. This is the vocabulary of invisible wounding. In 1974, these waves rippled across Cambodia's capital city of Phnom Penh during a particularly deadly battle at the end of the dry season. With fury in their hearts after years of living under aerial bombardments, the Khmer Rouge guerrillas blasted the city using big American 105 mm howitzers they had acquired on the black market. In retaliation, the U.S.-backed Lon Nol army fought back with their American-made T-28 bomber planes. In the wake of the fighting, the fires came. They blazed through every street, every school, and every home in the city's northeastern residential district, not far from where my parents and two young brothers lived.

The 1974 bombardment of Phnom Penh is but one layer in the palimpsest of permanent war. In 2001, Afghanistan became a new, fiery battleground of this conflict. It burned under the fires of U.S. Operation Enduring Freedom until 2014, though that American occupation continues today, almost 20 years later. Like in Cambodia, the war in Afghanistan has left a legacy of ongoing debilitation and unspeakable grief: the largest amputee population in the world, a collapsed infrastructure, and ongoing waves of refugee exodus. Here, in Phnom Penh, in Kabul, there is a slow wearing down of the population, like water eroding a cracked surface. This permanent war also engulfs the lives of soldiers, who return home from war in states of shell shock yet eager to be thrust back into the hellfire. But who understands the brain health of the Afghani people?

LAND BRIDGE · In the imperial toolkit of permanent war, we also find the statecraft of sanctions. To sanction a country is to impose a cruel penalty on its people. Like Yemen today, disintegrating under the weight of a U.S.-backed Saudi war and the world's utter abandonment of its people to disease and starvation, Cambodia in the '80s was relinquished to a state of devastating famine. During the Khmer Rouge regime, Cambodian people, like my family, had lived off two bowls of rice gruel a day for almost four years, their capacity for resistance stunted and diminished. After the Vietnamese army — America's greatest enemy during this era — invaded Cambodia and deposed the Khmer Rouge in 1979, the West imposed a sanction on foreign aid to Cambodia. No food arrived in Cambodia. No medicine. Nothing. "We didn't have enough of anything," my mother once told me about this time of total insufficiency. The sanctions of war propelled a spiralling exodus of refugees. Some wanted to leave Cambodia forever; others just walked toward the border in search of food that could not reach the interior.

What emerged was the *Cambodian land bridge*, a flow of Cambodian people overland from the northwestern regions of Cambodia to the refugee camps at the Thai border. A term originating from the field of biogeography, a land bridge refers to a strip of land that forms across an expanse of water, linking two previously unconnected land masses. The formation of a land bridge allows for a new circuit of migration to take shape. From 1979 to 1980, Cambodian men, women, and children walked for days to pick up rice, seeds, and tools that had been stockpiled at the border camps. They carried heavy bags of rations on their heads, traversing a dangerous path of landmines, warring militias, checkpoints, dehydration, and jungle hazards along the way. How many women, like my mother, were carrying food on their backs and new life in their wombs as they walked? In the image of the land bridge, the ingenuity of refugee survival is laid bare alongside the scourge of permanent war. Backward from Cambodia to Laos, Vietnam, and Korea, and forward to Afghanistan, Syria, and Yemen — how far can this bridge wind on?

FROM CONFLICT TO PEACE: MAKING A SOCIETY MORE WHOLE

HOI KONG

Art by April dela Noche Milne

In societies riven by conflict, sometimes violently, it can be difficult for groups to arrive at lasting settlements that will allow them to live together in peace. These kinds of conflicts are crises that tear holes in the fabric of a society.

Often unscrupulous politicians, media, and other powerful interests want to perpetuate conflict because they are invested in the status quo. They can therefore overstate the extent and depth of disagreements and exaggerate the obstacles to peace.

In contrast, the general population can often be tired of conflict and may agree on general, shared values that can form the bases of a settlement. For example, there may be consensus among members of diverse groups that basic human rights should be respected, that every group — ethnic, linguistic, religious, and other — should be able to live in cultural and physical security, and that no group should be subject to the arbitrary power of another.

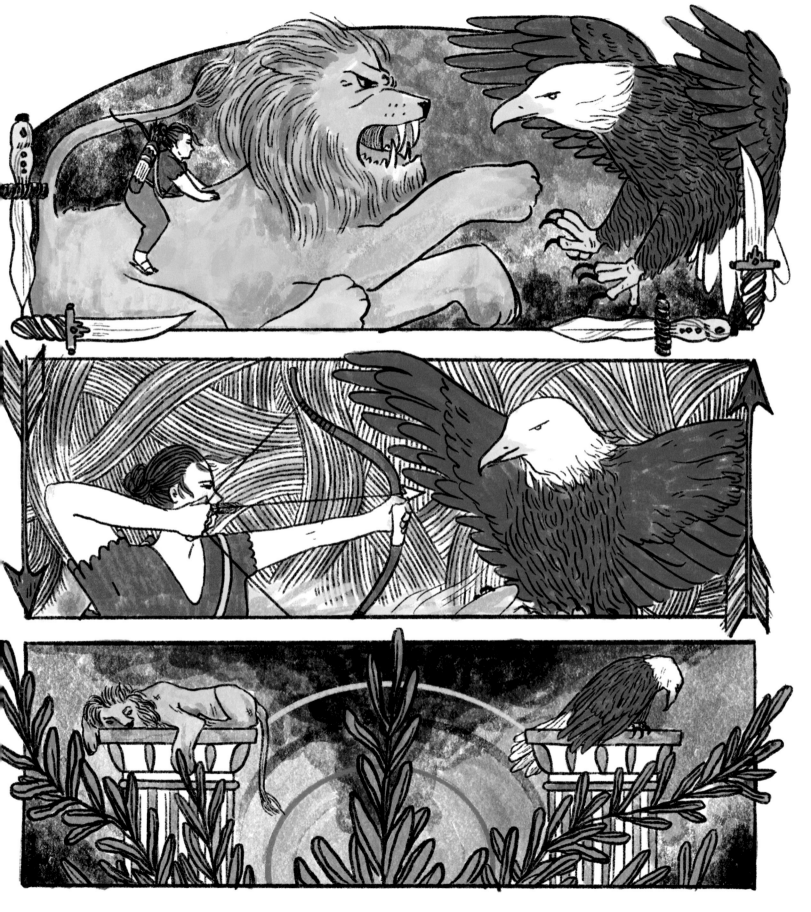

Because these kinds of conflicts can shake a society to its foundations, any lasting settlement will need to establish a new set of societal commitments and basic political institutions. It will need to take the form of a constitution. Constitutions articulate basic shared values, provide for institutions that govern and manage conflict, and are fundamental in the sense that they normally prevail over all other rules in a jurisdiction and aim to last for a long time.

The *deliberative peace referendum* is an innovative proposal for overcoming the resistance of entrenched interests and asking the general public to identify shared values that can shape a new constitution. This kind of referendum will typically provide for *mini-publics*, gatherings of ordinary citizens selected to represent equally groups that are party to a conflict. Citizens in these mini-publics will deliberate about what values (e.g., human dignity, mutual toleration, democracy, the rule of law, etc.) should be placed on a referendum ballot. They will be guided in their deliberations by facilitators and informed by experts on relevant constitutional, economic, social, and political issues.

Typically, one part of the deliberative peace referendum ballot will identify constitutional values and ask voters to rank them; another part will ask whether elected representatives of groups should be mandated to negotiate new constitutional arrangements in light of these ranked values. The mandate question acknowledges that members of the general public do not generally have the political experience necessary to negotiate the details of a constitution. And a mandate to negotiate only in light of popularly decided-upon values aims to constrain politicians from pursuing their narrow self-interests, including any interest they may have in perpetuating conflict.

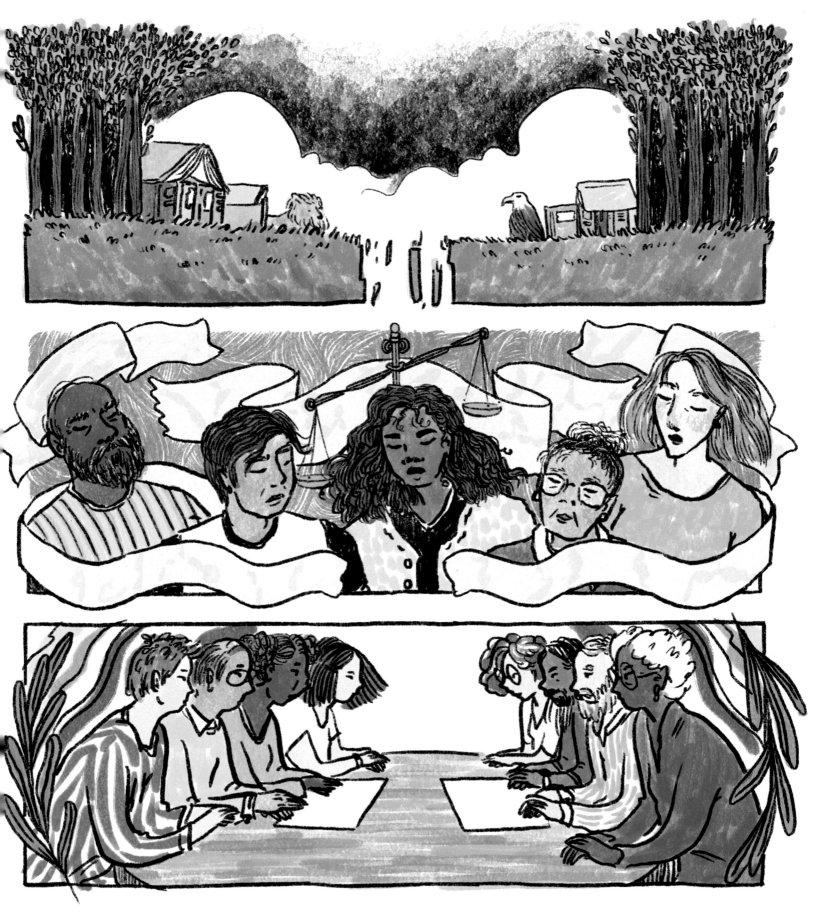

Let's consider what deliberative peace referendum campaigns might look like. They will in general aim to minimize misinformation and limit the influence of powerful interests. A trusted, impartial body — perhaps appointed by an international organization — may correct misinformation. Another institution — made up of ordinary citizens and advised by experts — may assemble information packages that will be delivered to each eligible voter. Spending limits can curb the influence of powerful economic interests. So, too, can laws limiting which parties are authorized to participate in a referendum and receive public funds.

If majorities of all relevant groups vote in favour of a mandate to negotiate, then representatives will negotiate constitutional arrangements in light of the values decided on by the referendum. The general public may have input into negotiations, and all relevant groups may vote on the results of the negotiations. If ratified by majorities in these groups, a new constitutional order will be established.

The above is a general outline of deliberative peace referendums. It will need to be refined or substantially changed in response to specific circumstances. For instance, in some contexts it may not be easy to clearly define who is a member of a given group, and referendum designers will need to be aware of this challenge. And indigenous-settler conflicts will require careful design, because they often present concerns about incommensurable values and colonial denials of prior sovereignty. Discussion of these complications and others, as well as more detail about deliberative peace referendums, can be found in *Deliberative Peace Referendums* (Oxford University Press, 2021) by Ron Levy, Ian O'Flynn, and Hoi L. Kong.

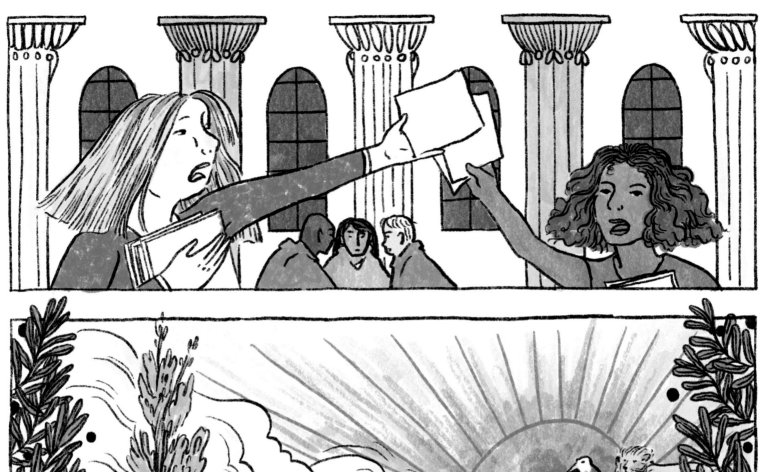

THE LEGACY OF RACISM AND SEXISM IN SCIENCE

SHEILA TEVES
Art by Andrea Alcaraz

THE MISSING SCIENTISTS • As a student, I learned about the key scientific discoveries throughout history. The theory of relativity (Albert Einstein). The composition of the atom (Niels Bohr). The structure of DNA (James Watson and Francis Crick). Nothing sums up these discoveries more completely than the Nobel Prizes. I was awed by the brilliance and genius of these scientific giants. But, looking through the prize winners, a glaring pattern emerges: they are overwhelmingly white and male. As a Filipina woman in science, I couldn't help but wonder why.

I am a scientist. I love what I do. The pursuit of knowledge. The insight to ask what is unknown. The logic of reasoning. The thrill of new discoveries. It's all so beautiful to me. But, ultimately, science is a human endeavour and hence is subject to the best and worst of human qualities. The best includes perseverance and inspiration. The worst is racism and sexism that has pervaded the scientific community for centuries.

In the 1700s, as scientists were classifying organisms into a hierarchy, they applied the same system to classify the human race. Carl Linnaeus, the father of modern taxonomy, classified white Europeans as the superior race, followed by Asians, Native Americans, and, at the bottom, Africans. And thus race science was born and used to justify racism for centuries, despite no scientific basis. We now know that there is no genetic component that encodes for race. Humans are more genetically similar to each other than chimpanzees are to other chimpanzees.

Science was also used to classify women as intrinsically inferior to men. One of the oldest scientific societies, the Royal Society of London, was founded in 1660. The first female scientist to be elected to this society was in 1945. The discovery of the DNA double helix structure for which Watson and Crick are celebrated? The data was collected by Rosalind Franklin and taken by Watson and Crick without her knowledge. The rampant sexual harassment and abuse in the science community is just now gaining public attention.

Throughout history, these biases have led to the exclusion of women and people of colour in the sciences. For centuries, science was done by, and for the benefit of, only white men. How many scientists have been missed? How many communities have suffered from being excluded from science?

THE NEED FOR AN EQUAL AND OPPOSING REACTION • People are becoming increasingly aware of the dangerous effects of racism and sexism to society as a whole. Movements such as Black Lives Matter, Women's March, and #metoo have gained widespread support worldwide. However slowly, change seems to be coming to our social beliefs and norms.

As science reflects our societal beliefs and concepts, the scientific community is slowly experiencing this change also. For instance, race science has been debunked, and its supporters largely ostracized. The MeTooSTEM (Science, Technology, Engineering, and Math) movement exposed sexual harassment and abuse that have been rampant in many scientific fields but were always swept under the rug until now. Though in the past individuals have championed these issues, more and more people are becoming engaged now and are remembering the hard lessons learned.

Change has to happen at all levels, especially at the start of children's education. Regardless of race or gender, children from all walks of life have the innate curiosity and capacity to excel in the sciences. But societal biases can exert their pressures even at this early stage. In one study, researchers found that teachers rated Black students lower in math and reading skills compared to white students, even though the students had identical test scores. Children also start out with less gendered science stereotypes. From five decades of studies of asking children to draw a scientist, researchers have found that the number of younger children drawing women as scientists have steadily increased throughout the decades. The effect is less prominent among older children, suggesting that as children grow older they increasingly associate science with men rather than women. These effects on children compound throughout their lifetime, making it all the more important to start early in changing our societal beliefs and norms.

A body in motion stays in motion, unless external forces are applied. Science will continue to reflect our best and worst qualities. Without committed action, no change will occur. And a body as large as the scientific community will need an equally large force to change its course.

HOW TO CREATE A HARVARD IN YOUR COUNTRY

MICHELLE STACK

Art by April dela Noche Milne

1 To the nations with no top universities, follow the advice of rankers and aspire to be the beacon of excellence: America. On your way, look to the next tier, if you must: the U.K., Australia, and Canada.

2 Make sure everyone understands world-class knowledge (i.e., what is counted by rankers) must be written in English and of interest to American and U.K. publishers.

3 Hire superexpensive Nobel Prize winners. Preferably go for ones with connections to pyramid-type schemes (e.g., Ignarro and Herbalife).

4 Raise pay for executives. Do this by raising tuition and increasing the number of insecure faculty positions.

5 Encourage GoFundMe campaigns to feed homeless students who can't pay the rising tuition fees and eat. Also give them workshops on how to budget. And provide them with a mindfulness app.

6 Publish lots of stories about bringing in dogs during exam time for reducing stress among students.

7 Work with admissions coaches to compete for the wealthiest students but, for goodness' sake, don't get caught (see Operation Varsity Blues). If you do, hire the top PR firm to get you out of the situation quickly.

8 Actualize your aspirations by creatively counting your full-time faculty members. Higher numbers are, of course, better for rankings. Go through a similar exercise of innovative organizational change in calculating student debt, graduation rates, money spent on students, etc.

9 Hire celebrity academics. Ignore cautions from their peers; they might not be respected in their fields but they bring in dollars and visibility (see Paolo Macchiarini at the Karolinska Institute).

10 Make sure to accept money from the super wealthy and in return let them influence hiring and research agendas. See MITs relationship with the Koch brothers for excellence in this regard.

11 Have a stellar alumni list that includes activists in the dark money network, war and corporate criminals. They often provide substantial largesse to their alma maters. See Harvard's Jeffrey Skilling, who was the proud CEO of Enron. He is in jail now, which doesn't often happen to the Harvard graduate.

Or Henry Kissinger, who brought even greater fame to Harvard as a talented war criminal and covered the country alphabet with his bombs and coups, from Argentina, Bangladesh, Cyprus, Cambodia, and right up to Zimbabwe.

Or Stanford alumni and multibillionaire Charles Schwab, who has generously donated millions to get rid of Obama and help Trump, another Ivy Leaguer, with his legal fees.

12 Have task forces on racism and hire advisors to run them. Do not provide them resources for the work. When people complain nothing has been done, blame the advisors. Fire them and announce a new task force.

13 Spend money on marketing your greatness. Branding is key. Highlight your Nobel Prize winners, celebrity academics, and money-makers. Rankers have consultants to help you in this area.

14 Find ways to keep climate change academics busy so they don't anger key investment partnerships with fossil fuel companies. Same for those who do research and get all hot under the collar about big pharma.

15 Show you are deeply committed to the future of the planet by putting out regular press releases stating your institution's unwavering support for climate action.

16 Get rid of the humanities (or at least close a few of their departments). They don't bring in revenue, and they encourage critical thought that is not conducive to the mission of being a top-ranked university.

17 Set clear guidelines for hiring, tenure, and promotion committees that spell out in no uncertain terms the definition of high interest. Sadly, too many confuse high impact for society (e.g. research on racism, corporate malfeasance, and human rights) with high impact sensitive to the aspiration of large donors. Correct this misunderstanding with vigour.

18 Ignore steps 1 to 17 and respond to global crises at your own peril.

THE DANGEROUS WORK

CARRIE JENKINS
Art by Carrie Jenkins

These days I want to do the dangerous work. I am playing with fire — literally.

Living through the COVID-19 pandemic, I found myself temporarily unable to write the text of my new book. Part of the problem was that the shift in the world left me feeling unstable, intellectually and emotionally. I couldn't imagine the future. As I put it to friends, I didn't know what kind of a world I was trying to write into.

So I turned to studying and practising visual art. Perhaps because this was relatively new to me, I felt able to use visual media experimentally and with more attention to process than product. With that came a freedom to focus on the present moment, and I ditched the felt need to project into an unimaginable and formless future. These three pieces developed from that process, in conversation with my cohort of Wall Scholars about the nature(s) of crisis.

Over the last few years I have begun to understand my academic work as a practice that includes creative elements. In my creative–academic work, my attention is often drawn to the academic world itself and particularly to the multiple intersecting crises that academia embodies, both day to day and in extremis. Crisis burns things down, and it leaves holes in things. These phenomena occur at every scale, from the cellular to the cosmic.

In *House of matches*, I created mixed-media images on paper of campus buildings, walls, and fences, based on parts of various university campuses around the world where I have lived and worked. I set fire to the images one at a time until the whole collection was burning. The archival piece is a collection of paper ash.

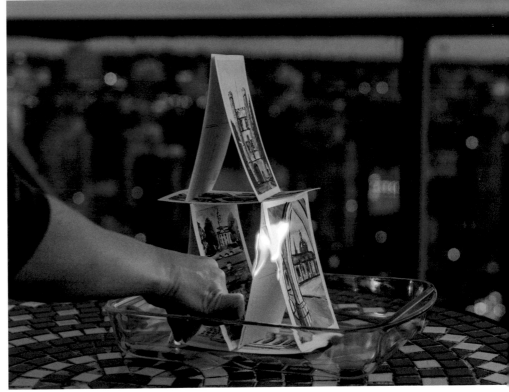

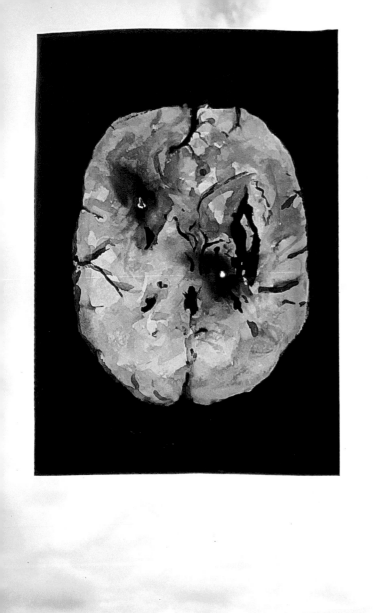

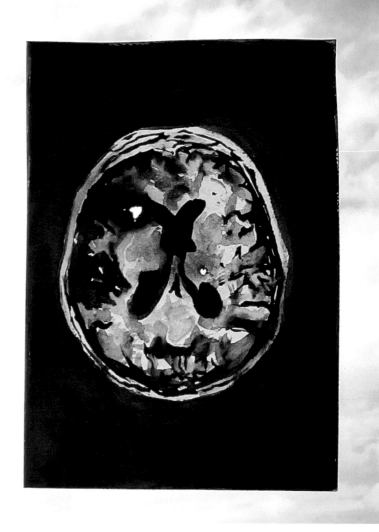

Burned out uses fire as a metaphor for hyperintensity. I made hand-drawn images of brains on paper, based on MRI scans — from the lab of Prof. Lara Boyd — showing lacunes, which are small dark areas that are the results of miniature strokes. I then used fire to make additional marks and holes in the paper.

In *Burned out again*, a similar effect was created by burning through other images:

— a human heart, inspired by Prof. Purang Abolmaesumi's work on imaging;
— a food cupboard, inspired by Prof. Jennifer Black's work on food insecurity;
— a population map, inspired by Prof. M.V. Ramana's work on nuclear power;
— a landscape, inspired by Prof. Y-Dang Troeung's work on war in Cambodia;
— some American paper money, inspired by Prof. Troeung's work and Prof. Michelle Stack's work on academic funding and rankings;
— a copy of Canada's constitution, inspired by Prof. Hoi Kong's work on constitutional crises;
— a lab team, inspired by Prof. Sheila Teves's work on exclusion in science;
— a hospital bed, inspired by Dr. Steve Reynolds's experiences providing front-line medical care during the pandemic;
— some academic textbooks and CVs;
— a personal diary;
— a human eye;
— a black hole;
— an image of the earth from space.

My burned images are chosen because they bear meaning in different ways, and I am fascinated by how meaning inheres, like magic, in its physical vehicles and how meaning changes as the vehicles change their physical properties. I am guided, too, by the interplay between *lacunes* in the sense of physical holes and *lacunae*, a technical term used in philosophy to indicate missing parts of an argument or theory. Some of the burn marks and holes appear on one image only, while others have burned through multiple papers at once. In the final installation, the burned papers are arranged so some of the images are only visible through the holes in others.

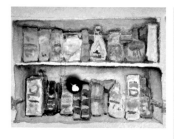
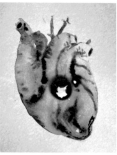
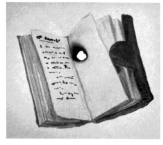
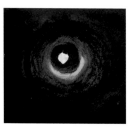
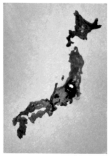

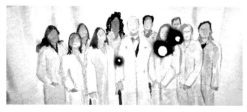

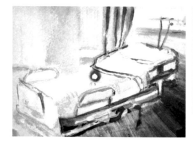

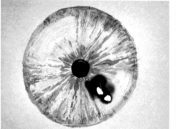

The COVID-19 crisis has made tangible all kinds of pre-existing fault lines and failings in our institutions. In parallel fashion, this project makes tangible some ideas I have been troubled by for a long time. Last year, I published *Uninvited: Talking Back to Plato* (McGill-Queens University Press, 2020), co-authored with Prof. Carla Nappi (Pittsburgh). This book is a collection of poems responding to our experiences of teaching Plato's *Symposium* to undergraduates. It is, in a sense, the result of those classroom experiences reaching a crisis point. But it is also a means by which we are "talking back" to the academy itself. As we say in one of the invitations at the end of our book: "Scholars are humans, and humans feel. Rage and joy and fear and passion and frustration are often what bring us to our objects of inquiry and draw the thoughts and words and voices from us. We work and think with our whole selves. We open ourselves to the world to pay the kinds of attention that help us to understand ourselves and each other more fully in the process. And attending to the world too closely, with eyes and skin and ears too open, is dangerous work."

ACKNOWLEDGMENTS

This book emerged from intense dialogues and serendipitous interactions during long walks and meals — and later Zoom chats — that took place during our time as Wall Scholars at the University of British Columbia (Vancouver, Canada). Our beautiful campus is located on the traditional, ancestral, and unceded territory of the xwməθkwəy̓əm (Musqueam) people, which is a source of inspiration.

This book would not have been possible without the meaningful engagement and contribution of the entire Peter Wall Institute for Advanced Studies team including the Wall Scholars cohort who worked collectively in a spirit of true collaboration, with dynamic guidance from Mary Rider, Robin Evans, Emma MacEntee, and Jazmin Welch, and the inspiring leadership of Kalina Christoff, and the creative drive of the artists — Andrea Alcaraz, Lay Hoon Ho, Carrie Jenkins, Sandeep Johal, April dela Noche Milne, Jess Stanley, and Ulrike Zöllner — who brought our thoughts to life.

PURANG ABOLMAESUMI

To Sharon, Iona, Roan, and Clover, who tolerated my endless hours of meetings during this pandemic year so my work could make a lasting impact. Special thanks goes to my partners in our point-of-care imaging network, front-line physicians, and patients across our province who inspired the writings in this book.

JENNIFER BLACK

I thank the teachers and care workers whose essential contributions made this book possible by caring for our children during a pandemic. Thanks also to Neil, Ren, and Sol Kursan, and Rosalyn Black for always nourishing Noah, Raffi, and me; and to Joe Black, my favourite artist. I dedicate this work to the care, inspiration, and brilliance of Sinikka Elliott; may her memory be a revolution.

LARA BOYD

For my girls who tolerate my endless curiosity and for my colleagues who inspire my questions.

CARRIE JENKINS

Thank you to my husband, Jonathan, who kept me fed. And to my dog, Mezzo, and my cats, Drusilla and Seven, who made sure I didn't get too much sleep.

HOI KONG

I thank Ron Levy and Ian O'Flynn, from whom I learned so much in co-writing *Deliberative Peace Referendums*. I also gratefully acknowledge funding from the Social Sciences and Humanities Research Council of Canada and the excellent work of a dedicated team of research assistants. And thank you to Ramona for being willing to listen to still more about deliberative democracy.

M.V. RAMANA

Thank you to Geetha, Swara, and Shruti for tolerating my hogging of the internet bandwidth and to our dog, Bubbles, for giving me time off from playing with her. Also thanks to Saya Soma and ann-elise lewallen for improving the accuracy of translation from Japanese.

STEVEN REYNOLDS

This year has been hard and I am thankful to the people that have stood with me. My fellow scholars for sharing their brilliance and welcoming me. Kalina for her leadership, kindness, and vision. My children Clare and Quinn for their sense of adventure. My buddy Russ for trying to keep me healthy. Most importantly for my wife, Jen, for her love.

MICHELLE STACK

Thank you to the amazing PWIAS cohort, to artist April dela Noche Milne for her cool artwork, to David for his support, to Penelope Lorimer Brown for calling me to share excellent jokes, to Theo Lorimer Brown for showing me his treasured bus on regular Zoom calls, and, of course, to their parental unit, Claire and Carl.

SHEILA TEVES

Thank you to my husband, Andrew, for his unwavering support, especially in these times of crisis; to my colleagues for their inspiration; and to my dog, Harry, for providing much-needed comfort.

Y-DANG TROEUNG

Thank you to my husband, Christopher Patterson; my mother and father, Yok and Heung Troeung; and to my son, Kai Basilio Troeung. Thank you also to Colin Grafton and Keiko Kitamura in Cambodia for assisting me with the research for this essay.

ARTISTS

ANDREA ALCARAZ
andreaalcaraz.com

Leaky Pipeline: Racism and Sexism in Science

LAY HOON HO
artyguava.com

Food in Crisis

CARRIE JENKINS
carriejenkins.net

Foreword Artwork
2020 Wall Scholars Group Portrait
The Dangerous Work

SANDEEP JOHAL
sandeepjohal.com

Birds of a Feather I
Birds of a Feather II
Birds of a Feather III

APRIL DELA NOCHE MILNE
aprilmilne.com

lacune
penumbra
recovery

exhaustion
(a multitude of)
a new order

untitled 1
untitled 2
untitled 3

JESS STANLEY

jessstanley.ca

Acceptance
Spiral
Uplift

ULRIKE ZÖLLNER

ulrikezoellner.com

Fukushima – broken reactor on nuclear power plant
Hypothetical radioactive scenario Japan – map
Wild boar – Futaba Town Japan

Bomb crater Cambodia – Kandal Province
Cambodian Land Bridge